D0492678

SKY HIGH
SUFFOLK COAST
AN AERIAL JOURNEY

MIKE PAGE

First published in Great Britain in 2009

Copyright text and photographs © 2009 Mike Page

All rights reserved. No part of this publication may be reproduced, stored in a retrieval system, or transmitted in any form or by any means without the prior permission of the copyright holder.

British Library Cataloguing-in-Publication Data
A CIP record for this title is available from the British Library

ISBN 978 1 906887 58 2

PiXZ Books
Halsgrove House, Ryelands Industrial Estate,
Bagley Road, Wellington, Somerset TA21 9PZ
Tel: 01823 653777
Fax: 01823 216796
email: sales@halsgrove.com

An imprint of Halstar Ltd, part of the Halsgrove group of companies
Information on all Halsgrove titles is available at: www.halsgrove.com

Printed and bound by Grafiche Flaminia, Italy

Introduction

Mike Page, through his superb aerial photographs, has produced a number of bestselling books of Norfolk and Suffolk from the air, delighting and informing thousands of readers. Of particular fascination in Suffolk are the dramatic changes in the coastal landscape due to erosion. Mike's intimate knowledge of the region and his interest in flying and photography make him particularly well qualified to create this fine collection of aerial pictures. In this book the reader is offered a visual memento of the Suffolk coast using new photographs specially selected by the author. Both for those who know the Suffolk Coast well, or for those who are visiting on holiday, this gem of a book provides the perfect keepsake.

Mike Page began his working life as a boat builder but in 1973, in partnership with his wife Gillian, began a garage business at Strumpshaw, east of Norwich. He's now semi-retired and his son Martin runs the garage, which gives him more time to pursue his flying and photographic interests. Mike's books with Halsgrove include *A Broad's Eye's Eye View I*, *A Broad's Eye's Eye View II*, *Norfolk Coast from the Air* (2 volumes), *Suffolk Coast from the Air* (2 volumes), *Sky High Norfolk Coast*, *Norfolk's Railway Heritage* (in association with Richard Adderson and Graham Kenworthy) and *Norwich from the Air*.

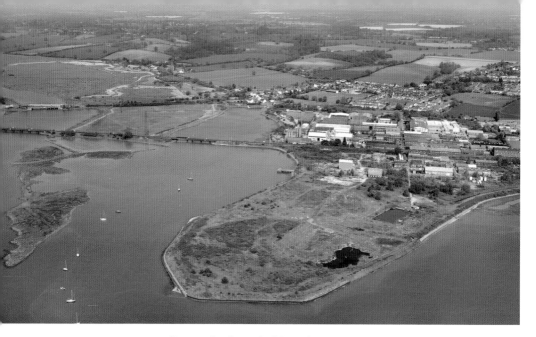

Cattawade, the end of River Stour navigation.

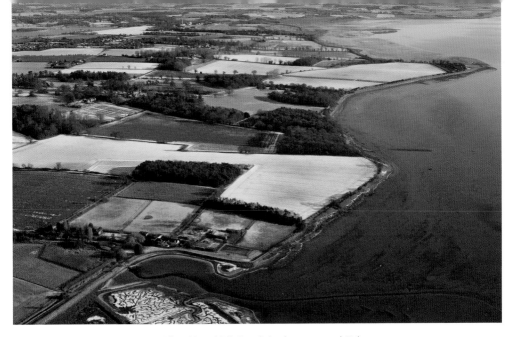

Stutton Mill & New Mill Creek looking toward Felixstowe.

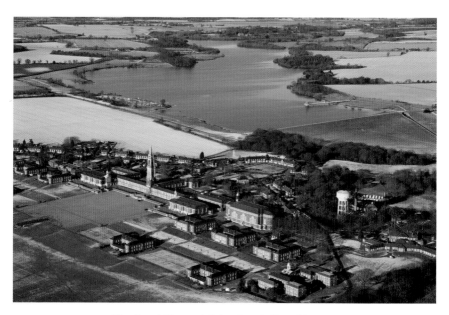

The Royal Hospital School and Alton Water.

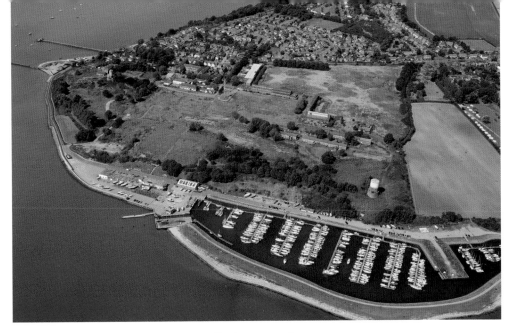

Shotley peninsula.

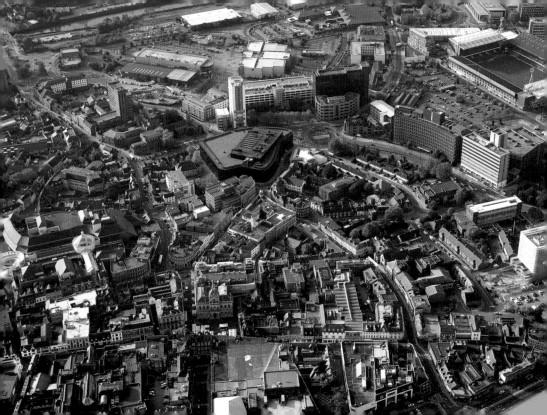

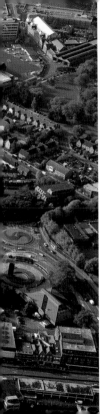

Left:
Ipswich.

Right:
The Orwell bridge.

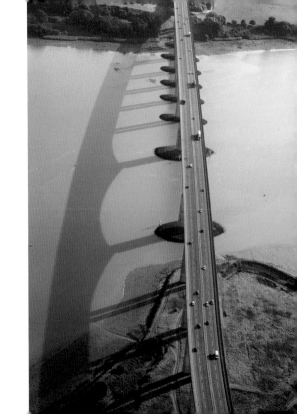

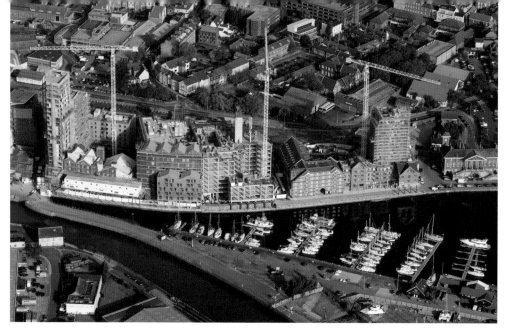

Ipswich waterfront developments.

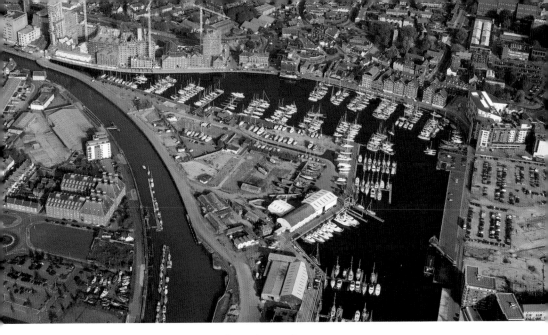

Ipswich waterfront.

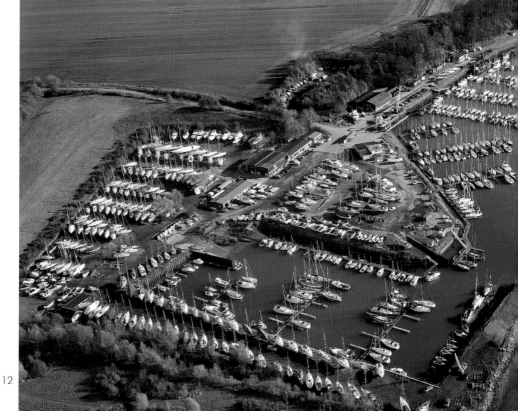

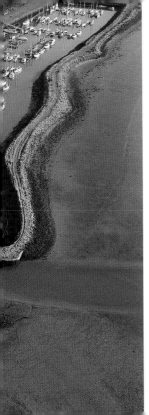

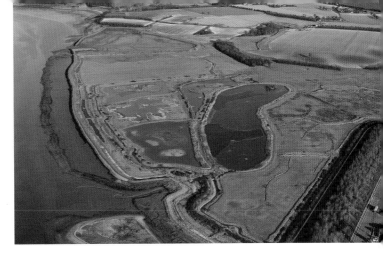

Trimley marshes reserve with Trimley village top right.

Opposite:
Levington marina.

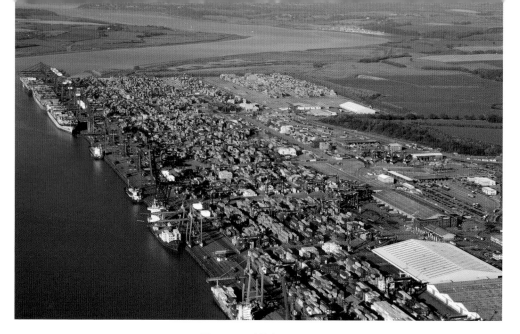

The port of Felixstowe.

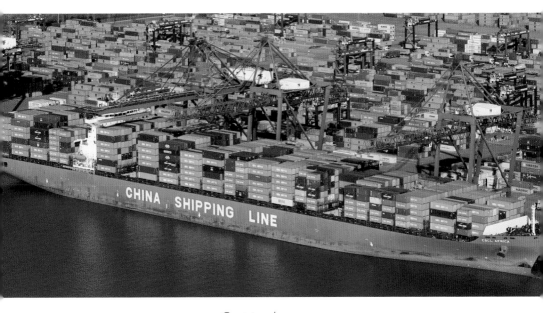

Container heaven.

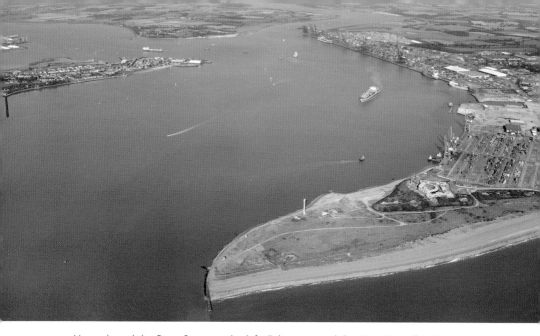

Harwich and the River Stour on the left. Felixstowe and the River Orwell to the right.

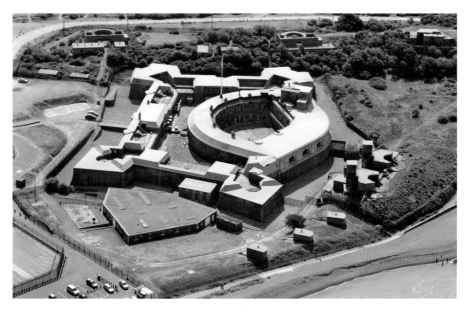

Landguard fort.

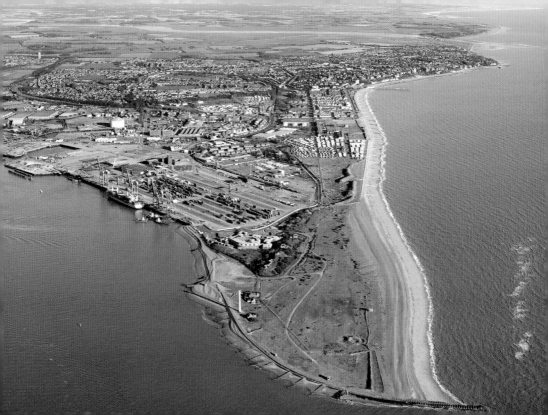

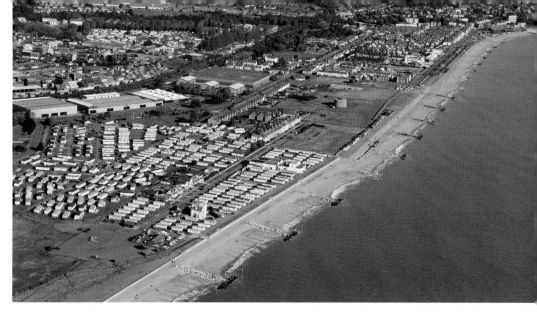

New sea defences, Felixstowe, completed in October 2008.

Opposite:
Looking north over Felixstowe from Landguard Point.

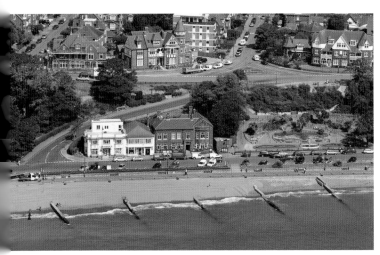

Undercliff Road and promenade, Felixstowe.

Opposite:
Cobbolds Point looking towards Bawdsey.

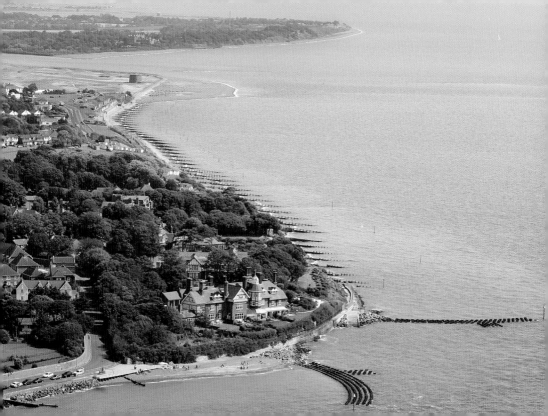

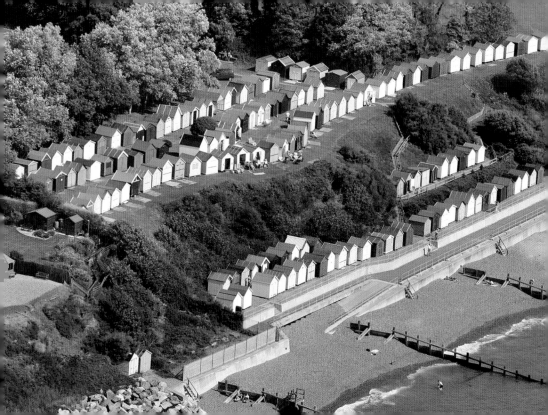

Left:
Beach huts are always popular on this coast.

Right:
Mouth of the River Deben.

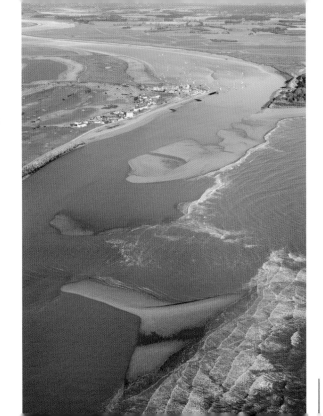

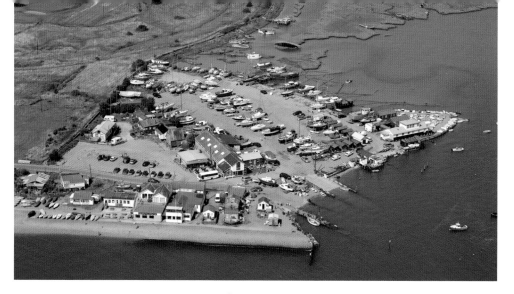

Felixstowe Ferry.

Opposite:
Thames barge *Pudge* on the Deben.

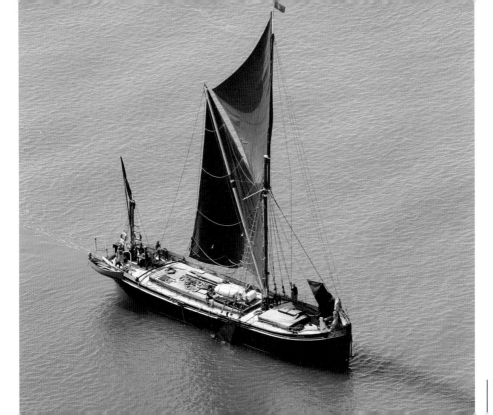

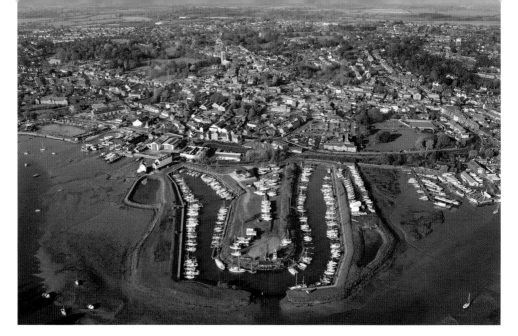

Woodbridge looking west.

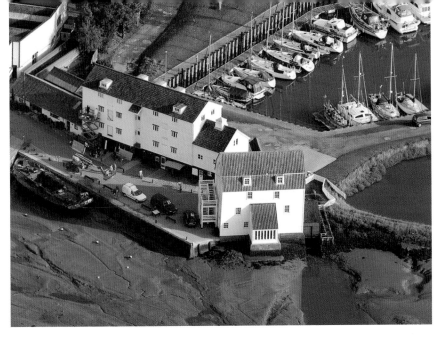

Woodbridge tide mill.

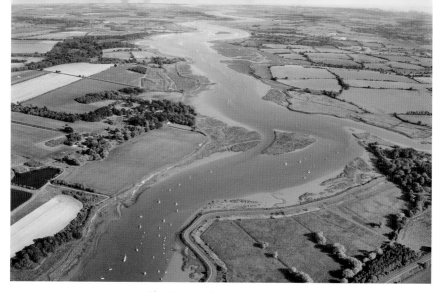

The River Deben to the sea.

Opposite:
Bawdsey quay.

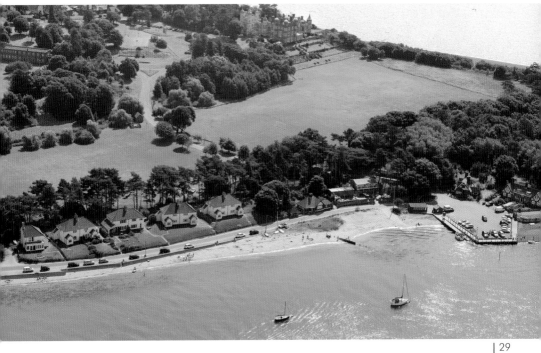

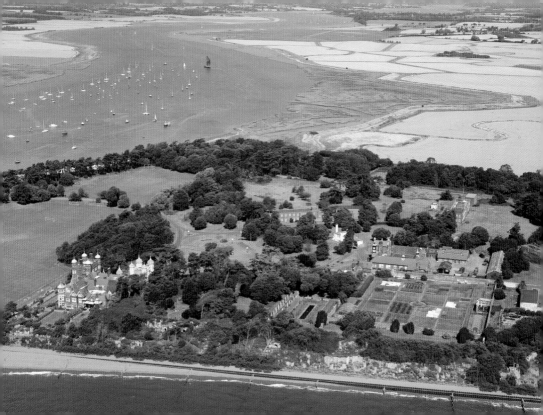

Left:
Bawdsey Manor
looking west.

Right:
Bawdsey looking north.

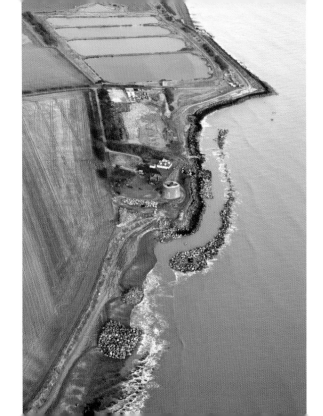

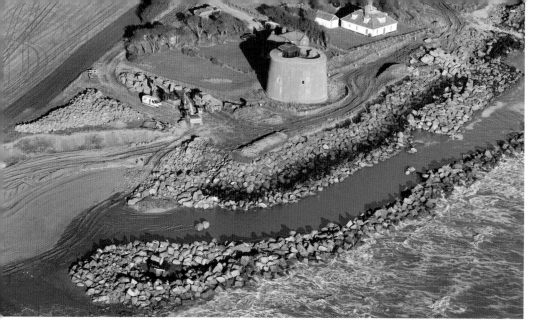

Bawdsey Martello sea defence repairs 2009.

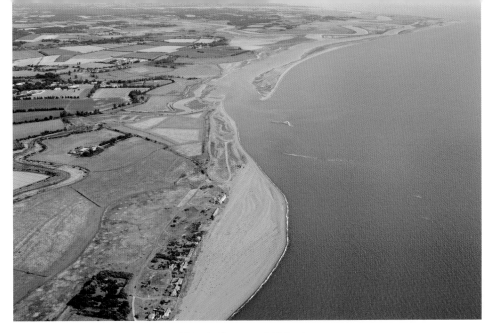

Shingle Street and Orfordness.

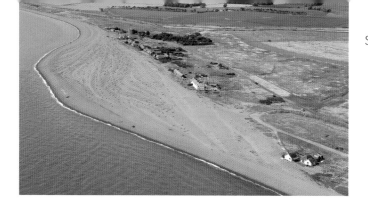

Shingle Street looking south.

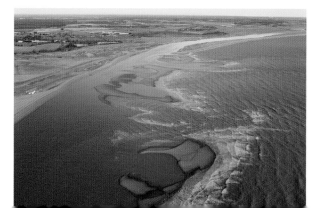

The entrance to the
River Ore can be tricky
due to shifting sands.

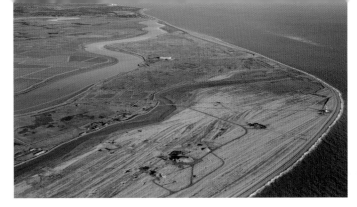

Orfordness towards Aldeburgh.

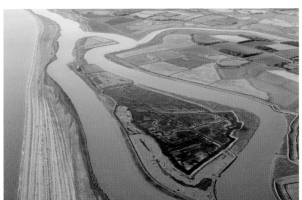

Havergate Island RSPB reserve.

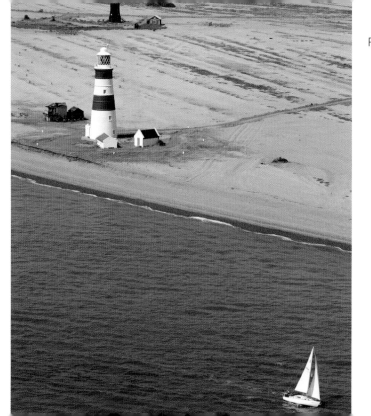

Passing Orfordness lighthouse.

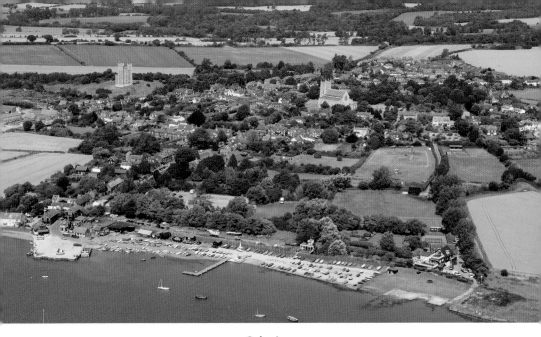

Orford.

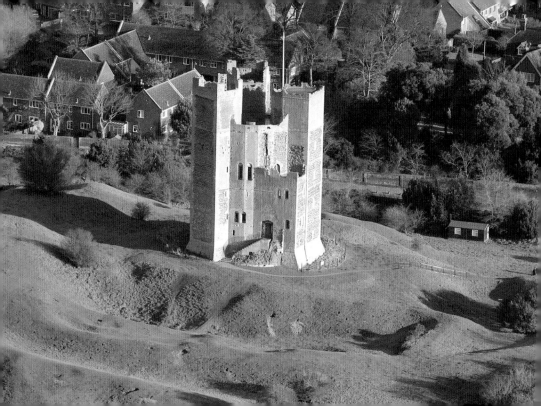

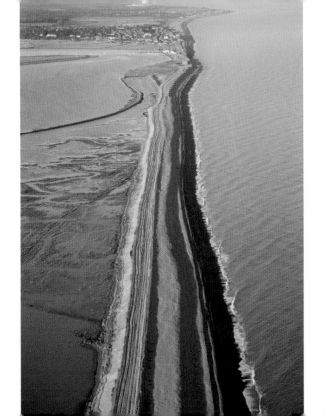

Aldeburgh shingle spit.

Opposite:
Orford Castle.

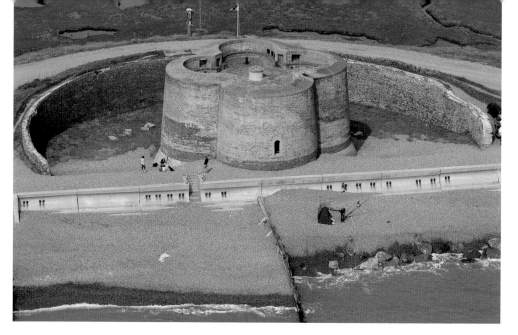

Aldeburgh Martello tower.

Aldeburgh looking north.

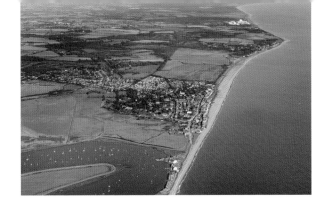

Aldeburgh looking west along the River Alde.

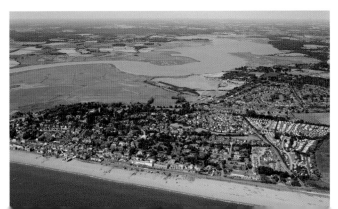

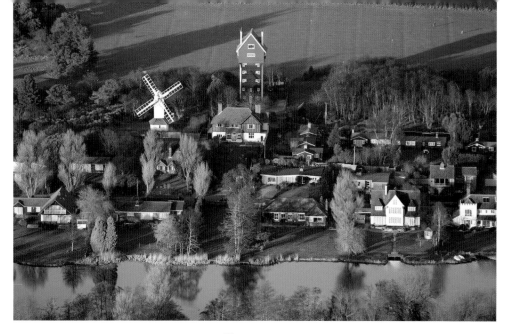

Thorpeness.

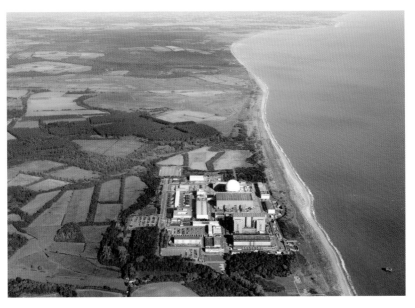

Sizewell looking north.

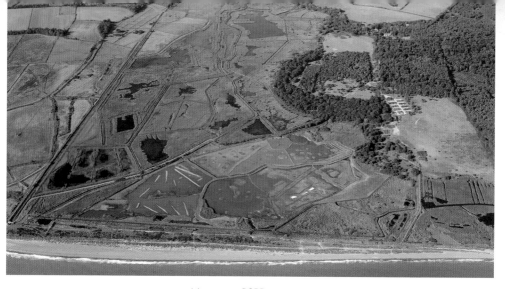

Minsmere RSPB reserve.

Opposite:
Dunwich Heath, heather in bloom July.

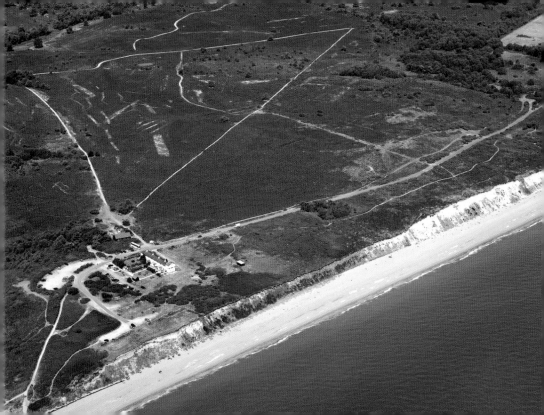

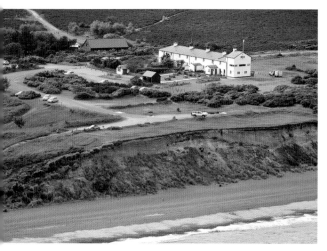

Dunwich coastguard cottages, National Trust.

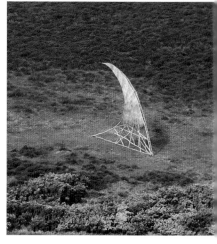

Sculpture on Dunwich Heath in
May 2008.

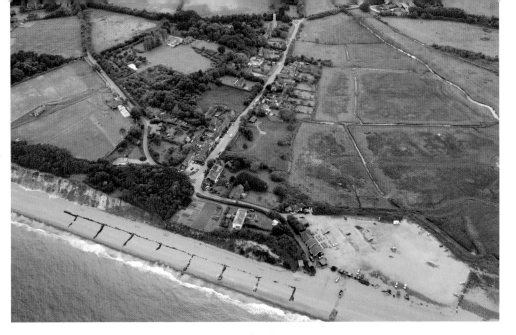

Dunwich Village.

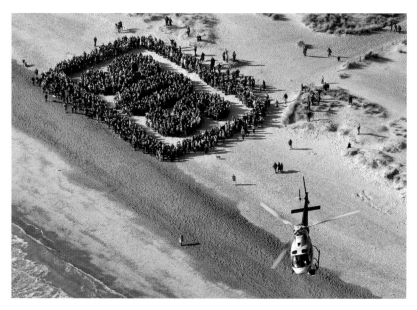

SOS. People of Walberswick protest to the government
and DEFRA to secure the sea defences.

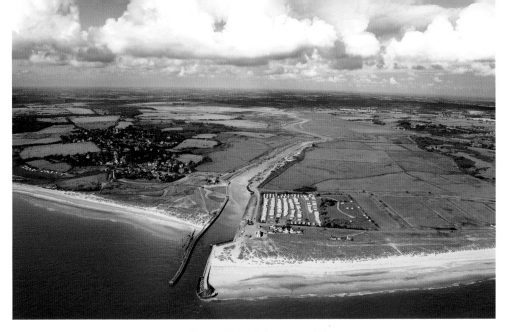

Walberswick and the River Blyth.

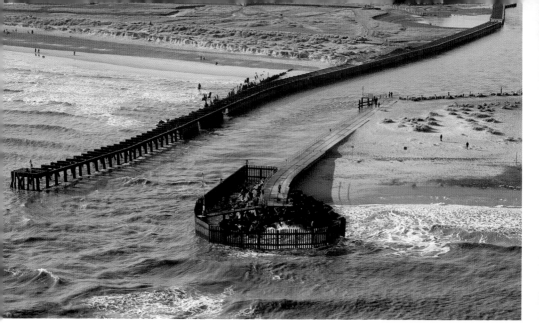

Entrance to the River Blyth.

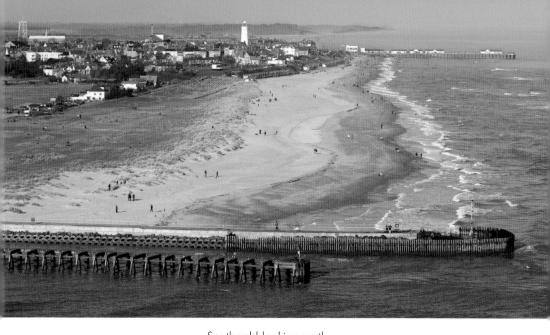

Southwold looking north.

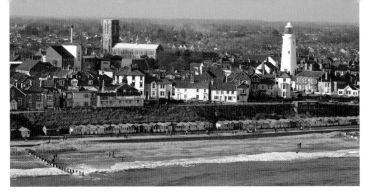

Southwold.

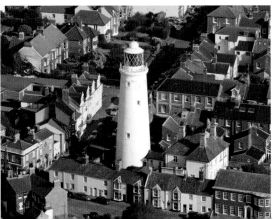

Southwold
lighthouse.

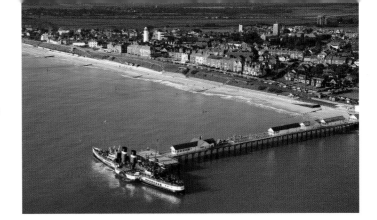

Paddle steamer *Waverley*
is a regular visitor to
Southwold.

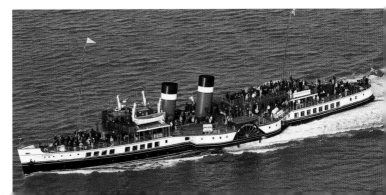

Waverley leaves Southwold
for the River Thames.

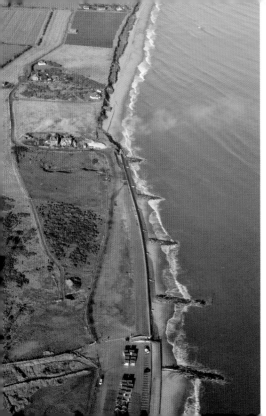

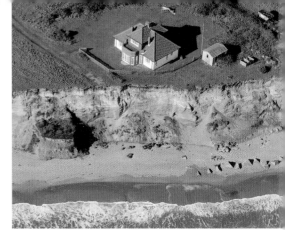

Above:
Easton Bavents where coastal erosion
eats away at the soft sand and cliffs.

Left:
Easton Bavents.

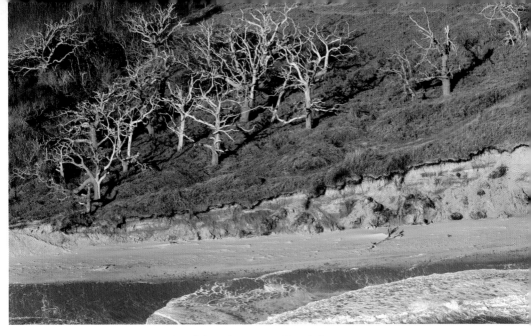

Death by salt water at Covehithe.

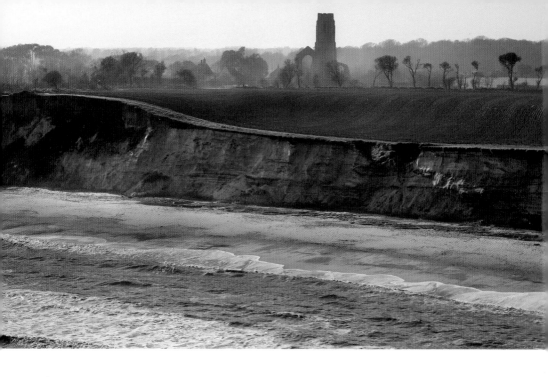

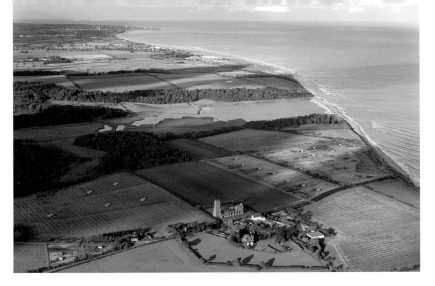

Covehithe looking north to Kessingland and Lowestoft.

Opposite:
Covehithe cliffs.

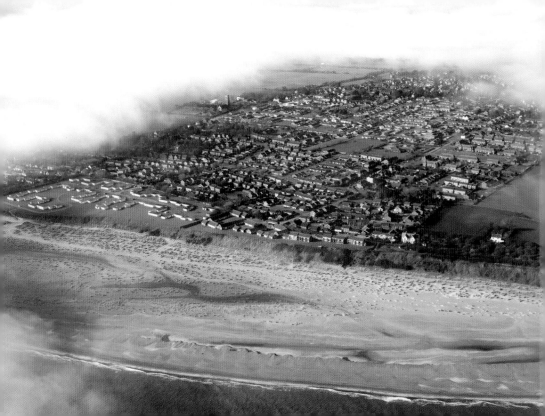

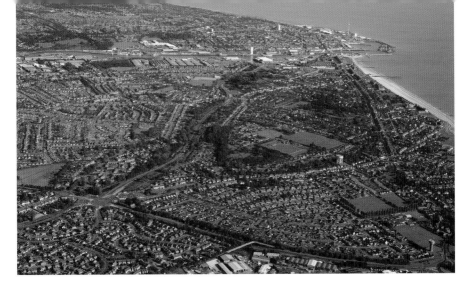

Lowestoft & Pakefield.

Opposite:
Kessingland avoids the autumn fog bank.

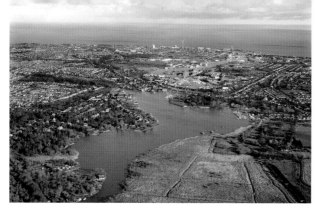

Oulton Broad and
Lake Lothing.

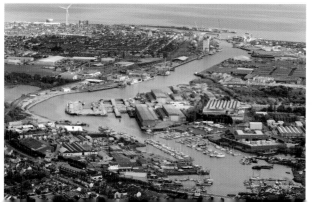

Lake Lothing to the sea.

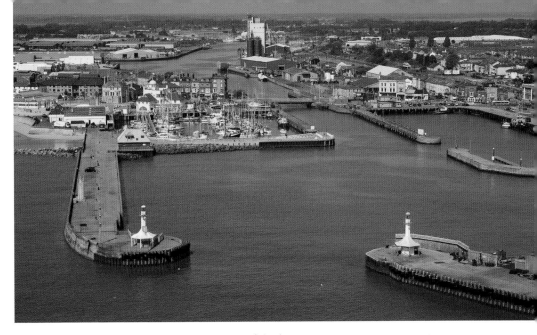

Lowestoft harbour.

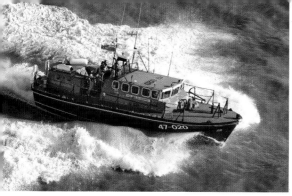

Above:
RNLI lifeboat *Spirit of Lowestoft* on exercise
off Lowesttoft.

Right:
Lowestoft looking north towards Great Yarmouth.

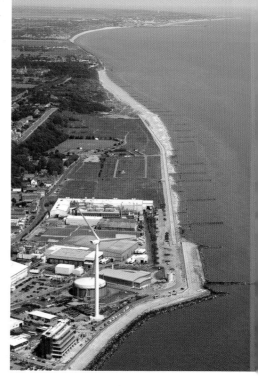

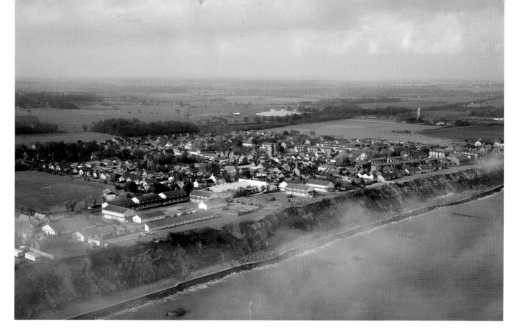

Sea fog at Corton. The swirling fog disguises some of Corton's crumbling cliffs. Large stones have been positioned at their base to break the force of the waves.

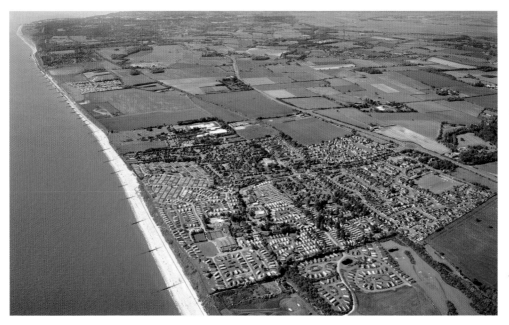

Hopton looking south toward Suffolk. Hopton marks the boundary between Norfolk and Suffolk